Introduction to

Archival Organization and Description

Michael J. Fox
Peter L. Wilkerson

Edited by Susanne R. Warren

Getty Information Institute

Cover image: Plan of a plantation belonging to Joseph Manigault. From 1824 survey. From the collection of the South Carolina Historical Society.

The URLs cited this publication were current at press time, but are subject to change. For up-to-date URLs, please visit the Web version of this publication at www.gii.getty.edu.

Design by Hespenheide Design

Library of Congress Cataloging-in-Publication Data
Fox, Michael J. (Michael Joseph),
1946–
Introduction to archival organization
 and description / Michael J. Fox,
 Peter L. Wilkerson; edited by
 Susanne R. Warren
 p. cm.
 Includes bibliographical
 references (p.).
 ISBN 0-89236-545-5 (alk.
 paper)
 1. Archives—Processing.
2. Archival materials. 3. Cataloging
of archival materials. I. Wilkerson,
Peter L. II. Warren, Susanne R.
III. Title.
CD971.F69 1998
025.17′14—dc21
 98-38502
 CIP

Acknowledgments

This publication is the result of the collaborative efforts of a distinguished group of archival practitioners and educators who have contributed their knowledge, insights, and experience to produce what we believe will be a tool useful to the archival profession. Special thanks go to authors Michael J. Fox of the Minnesota Historical Society and Peter L. Wilkerson of the South Carolina Historical Society, and to reviewers Timothy Ericson of the University of Wisconsin, Kris Kiesling of the University of Texas, and Helen Tibbo of the University of North Carolina for the effort and collective wisdom they have brought to this project.

Special thanks to Patricia Young for her support and guidance in this project. Thanks also to Nancy Bryan and Michelle Futornick of the Getty Information Institute, who were instrumental in bringing the manuscript to its final form.

Contents

Foreword

In October 1996, the Getty Information Institute invited educators and practitioners from museums, archives, libraries, and visual resources collections to discuss new directions in cultural heritage information. The meetings focused on electronic information that can be cooperatively developed and shared for easy access by a wide range of users. All of the participants identified a need for instructional materials to train novices and better educate decision-makers charged with the care of cultural heritage collections. The Institute's 1995 *Introduction to Imaging* was specifically cited as an effective model for additional practical field manuals for use in academic settings and training situations.

With that impetus, the Information Institute has published three additional guides in the Introduction to . . . series: *Introduction to Archival Organization and Description*; *Introduction to Vocabularies: Enhancing Access to Cultural Heritage Information*; and *Introduction to Metadata: Pathways to Digital Information*. These publications describe the framework of standards and terminologies that can make integrated access to cultural heritage information possible.

As global information networks proliferate, more and more people will have the opportunity to use and benefit from archival resources and the wealth of historical, social, and contextual information they offer. But these resources will be truly accessible and meaningful to users only if standards and structured vocabularies are in place to organize, catalog, and access this information.

Introduction to Archival Information and Description is intended as a contribution to what must necessarily be a collaborative effort by those compiling archival information and making it available to the global information community. As part of the Getty Information Institute's mission to strengthen the presence, quality, and accessibility of cultural information on networks, we are pleased to make this volume available for teaching and learning about archival documentation.

Eleanor Fink
Director
Getty Information Institute

Introduction

Archival collections offer challenges to those charged with their care and management, different from those associated with other types of cultural heritage artifacts. Each is unique, having been created at a particular time, by particular organizations or individuals, as the result of a particular activity or activities. The particular intersection of people, time, actions, and events that generates a collection cannot be replicated. If the cultural record contained in each unique collection is to be made accessible, it is necessary to examine, organize, and describe each collection individually. And this must be done with particular attention and sensitivity to the context in which the collection was created, its provenance.

Over the years, archivists have developed principles governing their actions as custodians of these unique collections. These principles have evolved into common practices that are both flexible enough to accommodate the variety inherent in archives and standardized enough to provide the consistency that is required, particularly in the increasingly networked electronic environment. Over the years, the archival profession has evolved a number of vehicles for educating current and aspiring archivists in the subtleties of this work: formal training is offered in colleges and universities, training opportunities abound at national and regional archival conferences, a substantial bibliography on archival practice has developed, and internships and on-the-job training provide necessary hands-on experience.

This publication is intended to serve as an introduction to these more detailed learning opportunities. By mastering the basic concepts outlined here, the reader will be better equipped to take advantage of other, more formal learning opportunities. It serves as an orientation to fundamental archival principles for beginning and novice archivists, and demonstrates how the work of the archivist flows from them. To that end, the publication begins with a discussion of cultural heritage documentation and the nature of archival information and documentation, in particular, as well as the fundamental principles of provenance and original order.

The chapters that follow cover such topics as the characteristics of archival materials and how these shape practice, the gathering and analysis of information that will go into description, types of finding aids, the standards and tools used to create these descriptive tools, and their deployment in information systems. The chapter on Archival Processing describes how the various tasks outlined in the publication fit together to result in the finding aids that provide access to the contents of archival collections. The tutorial provides a narrative description of how an archivist works through the sequence of activities of processing a collection, and illustrates the decision-making process that engages the archivist in this work.

Susanne R. Warren, Editor

Part I Archival Principles, Archival Practices

Archival Documentation

What Is Documentation?

Cultural heritage institutions—whether archives, libraries, or museums—gather, preserve, and interpret the record of human thought, word, and action. The collections of these institutions come in many forms and are managed according to different curatorial traditions. Yet archivists, librarians, and curators share mutual activities that reflect common social, administrative, fiduciary, and legal responsibilities. Among these is the need to document the origins, nature, and physical characteristics of the materials they collect and preserve.

Among archivists the term *documentation* has several meanings. It refers to a process: a broad range of activities undertaken in order to create descriptive tools to make collections easier to use, to establish the authenticity of holdings, and to satisfy administrative needs. Documentation can also denote the products of this process, the descriptive tools themselves: inventories/registers and catalog records. Finally, the materials in archival collections can be considered documentation in that they provide documentary evidence and information concerning people, events, activities, objects, and ideas.

Why Document?

There are three primary reasons for documenting the collections of cultural heritage materials.

- To facilitate users' discovery of materials
- To establish the authenticity of holdings
- To satisfy administrative needs

Facilitate user discovery

Archives preserve the historical record so that it can be consulted. To that end, documents are organized and identified so that researchers and institutional staff can locate the materials they require. Users come to archival collections with different needs. Some pose specific questions for known items: "I would like to see Mary Richardson's naturalization certificate." Other requests are more open-ended: "What information do you have on the licensing of physicians' assistants?" Or, "What records in your archives are relevant to urban renewal projects in downtown Buffalo?" The descriptive tools such as the catalog records and inventories/registers created by archivists bring out important information about collections to guide users in this process of discovery.

Authentication and reliability

The collections in cultural repositories are the tangible evidence of particular activities: the writing of an essay, the taking of a photograph, the painting of a picture, or the naturalization of a new citizen. But are these materials what they seem to be? To establish the authenticity of the documents and items in their care, archivists must compile evidence of the origins, chain of ownership, and completeness of their collections. They may capture and convey this information in different ways: through background documentation, deeds of gift, records of administrative transfer, certificates of authenticity, and maintenance of the integrity of the physical and administrative order of the record.

Archivists add value to their collections by documenting the contents and maintaining information about them. Other sections of this publication describe the activities associated with gathering the information needed to describe, provide access, and establish authenticity, as well as the tools used to deliver this information to others.

Administration

Recording information about collections is also an administrative necessity. An effectively managed institution creates and maintains a record of the activities it carries out with respect to its collections: acquiring, processing, conserving, exhibiting, storing, loaning, and providing reference services. Collections are as valuable an asset as financial or human resources; this value is protected by means of appropriate administrative information.

What Does Archival Documentation Involve?

To make a collection useful to researchers, the archivist must undertake a variety of activities that will make the content accessible both intellectually

and physically. The following activities, which are known as *processing*, are necessary in order to provide that access.

1. Analyzing the materials to identify their origins, structure, and content.
 Assembling Documentation, on page 12.
2. Organizing and arranging the materials.
 Organization and Arrangement, on page 35.
3. Creating finding aids to provide access to the materials.
 Description: Conveying Information to Users, on page 18.

Archival Materials and Information

The Nature of Archival Information

Archives exist as evidence of human activity. From that central fact, certain principles of documentation follow:

- Archives as evidence
- Archives as information

Archives as evidence

It is a basic premise of archival practice that particular records, whether written, recorded, filmed, or photographed, are created and assembled in the natural course of human activity. An organization carries out its daily operations, an individual goes about his or her life, working, associating with others, pursuing personal and occupational interests. As part of these activities, documents are created, assembled, and preserved. They are evidence of what has transpired. The spontaneous nature of such evidence is both its defining characteristic and the source of its continuing utility and vitality. Although individual documents are created for a particular temporal purpose, it is the fact that they have been assembled and preserved as evidence of that activity that defines them as archival. The context in which the documents were created must be understood before their content can be interpreted.

Archives as information

While archives are evidence, they may also be used for other purposes unrelated to the circumstances of their original creation (for example, a government agency collects documents about the trucking industry as part of its regulatory activities). While such records are clearly evidence of that government function, they may also contain a wealth of information about trucking companies that is useful for business history or other secondary purposes.

Principles of Archival Documentation

- Respect des fonds/Provenance
- Original order

Principle of respect des fonds/provenance

The organic nature of archival collections gives rise to the central principle of the archival enterprise, *respect des fonds*. This concept is also referred to as the principle of *provenance*. Defined by French archivists in the early nineteenth century, and successively refined by the German, Dutch, English, American, Canadian, and Australian traditions, this phrase has been variously interpreted. It is the formal expression of the principle that an archivist must respect, and reflects the origins of the assembled materials as an integral and organic corpus of documentation. It is the central and defining concept governing the way archivists document and organize their collections. Originally developed as a guiding principle for archivists dealing with governmental records, the concept has taken root in other organizational archives, and is applied to the tradition of historical manuscripts, where the corpus of an individual's records is treated as a logical unit, one often referred to as a *fonds*.

If the contents of such records are intrinsically bound up with the life of the individual or the functions of the organization from which they emanated, and cannot be fully understood apart from them, it follows that those records must be retained as a body. This is a clear and straightforward principle that in turn dictates the nature of the documentation that the archivist must assemble, and the manner in which it is presented to the user. Who was the person who created or assembled these things? What was the nature of the organization that created these documents? What was the governmental function or life activity that produced these materials? Respect des fonds/provenance provides the cultural context in which the records become intelligible. It also serves as the basis for authenticating and assuring the reliability of the contents of the records.

In some cultural heritage contexts (e.g., the museum community) provenance is regarded as custodial history. In this publication, however, provenance is applied in the archival sense, defined above.

Principle of original order

Given the centrality of the concept of the organic nature of archival materials, it is not surprising that archivists are also highly concerned with the physical order of records. The organization and arrangement of records reveal much about the forces, activities, and functions that produced them. Where there is little or conflicting information about the individuals or institutions responsible, internal evidence may be the archivist's best

source of information about the documents. Preservation of original order is important, too, for validating their authenticity.

Unfortunately, not all materials come into archival custody in a discernible, let alone pristine, order. When a pre-existing internal organization is not apparent, or is actually counterproductive to the effective analysis and use of the collection, the archivist must construct a rational order that is sensitive to the nature and uses of the collection. On the other hand, the principles described earlier imply strongly (and archivists accept this as a matter of professional faith) that the materials not be arbitrarily divided and reorganized on other principles such as geographical focus, subject matter, or time period.

Archival Materials: How Characteristics Shape Practices

Drawing on archival theory and on experience, practice, and observation, archivists can identify distinct characteristics of archival materials that affect how these materials are organized and described in archival collections. While every collection may or may not possess all of these characteristics, those listed below are most frequently encountered during the examination of a collection. These characteristics in turn directly influence descriptive practices. Each of the characteristics of archival materials on the left is matched by a corresponding descriptive practice on the right.

Table 1. **Archival Materials and Practices**

Characteristics of Materials	Archival Practices
Items generated in the context of an activity	Provenance-oriented descriptions
See page 7.	See page 13.
Groups of items related to one another	Collective descriptions
See page 8.	See page 14.
Varied content	Content analysis
See page 8, bottom.	See page 16.
Varied formats	Different content standards
See page 9.	See page 27.
Large number of items	Summary descriptions
See page 9.	See page 16.
Lack of formal identification	Extract, extrapolate, interpret, compile
See page 9, bottom.	See page 9, bottom.

Items that are treated archivally are generated in the context of an activity

The most significant and distinguishing characteristic of archival materials is context. Documents are created or compiled as a result of some activity or function; as such, they are the evidence of the activities of individuals or corporate bodies. For example, individuals often keep receipts to

document expenses over the course of a year for income tax purposes. Department stores maintain inventory records to document what has been bought and sold. In both cases, the documents preserved reflect activity.

Provenance-oriented descriptions are written to reflect the individual or corporate body that created the materials, and to record the activities and functions that these materials document.

Individual items in a collection are related to other items in that collection

Archival materials exist as groups of related items. Unlike museum curators and librarians, archivists view their collections not as individual items but rather as groups of documents. While an individual item may be significant in and of itself, it is generally grouped together with other documents created by the same activity. Consider, for instance, documents generated in the course of buying a house. These may include a title to the property, loan papers, correspondence, inspection papers, and survey documents. Instead of focusing on each individual document, the archivist views such a group of documents as a record of the sales transaction.

Documents that are arranged in accordance with a filing system or maintained as a unit because they result from the same activity or accumulation or filing process, or because they have a particular form, or some other relationship arising out of their creation, receipt, or use, are called *series*. The relationships among the different document groups, or series, of a corporate body often mirror the structure of the organization. In the case of personal papers, on the other hand, there may be little structure to the organization of the materials, or the structure may be idiosyncratic, although structure and naturally occurring series may also be found in such collections.

Materials in archival collections can also be related to items in other collections. Documents that are created by different individuals or corporate bodies, but have some other characteristic, such as topic or context, linking them together are said to be *collaterally related*. For example, consider the case in which four soldiers create documents describing the same battle. The first soldier describes the battle in a letter home. The second soldier in the same unit keeps a private diary. The third soldier in the opposing army sketches scenes from the day's events, while the fourth records orders given and received that day. Each soldier's record is collaterally related by the context of the battle, although the individual documents may reside in four different archival collections.

Descriptions are written to characterize documents collectively in order to record and preserve the internal relationships among them.

Items in a collection contain information about topics, events, activities, or people

Because materials in archival collections are evidence of the entire range of personal and institutional activities and functions, the information

contained in them is diverse. For example, among the personal papers of an individual there may be groups of documents created as the result of religious, professional, and avocational activities. These papers may contain information about a particular church and its members, the accomplishments of committees on which the individual served, professional projects undertaken here and abroad, and papers and artifacts related to hobbies from bungee jumping to stamp collecting. Such diversity of content is commonly found in the personal papers of individuals.

Content analysis is conducted to extract this varied information so that it can be brought to the attention of the user. The more varied the information in the collection, the more extensive the analysis.

Items in a collection may be of many formats and types

A collection might consist primarily of material of one type, such as letters, or it may contain a mixture of material types such as computer files, photographs, maps, and textual records. A collection of documents relating to a wedding, for instance, may contain a marriage license, catering bills, invitations, registration books, photographs, and a video recording of the marriage ceremony and reception. Different formats and types of materials may require different descriptive practices and therefore use different descriptive standards.

Archival collections often consist of large numbers of items

Archival collections often consist of hundreds and even thousands of individual items. The larger the collection, and the more varied its content and material types, the greater the potential for complex internal relationships.

It is neither efficient nor necessary to describe each individual item in a collection. Instead, summary descriptions are written to represent and convey the primary content of the collection to the user.

Most collections lack any formal means of identification

Unlike books and other published materials, items in archival collections usually lack title pages or imprint information to identify that particular collection or group of documents. Archivists provide identifying information for collections. Because there is no formal identification, archivists extract, compile, and extrapolate information from the collection rather than transcribe information from a standardized source, such as a title page.

Part II Archival Analysis, Archival Description

Gathering and Analyzing Archival Information

Assembling Documentation

Archivists assemble documentation about collections so that users may understand a collection's scope and content. Researchers use the documentation to determine whether a particular collection contains information relevant to a specific research topic. To create the documentation, archivists:

- Analyze the materials to identify their origins, structure, and content
- Use information assembled during analysis of the collection to create finding aids that provide access to the materials

The proper documentation of a collection requires that the archivist acquire understanding of its origins, structure, and content. To this end, it is necessary to discover how the collection was originally organized (if it was organized at all); the context in which the collection was generated; and the relationship of the collection's content to other collections, people, and historical events.

The archivist analyzes the content and structure of the collection, gathering information that will form the basis of the finding aid. In addition, research in sources external to the collection provides information about the context in which it was created, which will also become an integral part of the final documentation.

What Information Is Collected?

During processing of the collection the archivist brings together the following information about the collection, in order to create descriptions:

- Information about provenance
- Information about order and organization of documents

- Information about physical extent and condition
- Information about scope and contents of the records
- Information about administrative matters

Information about provenance

To review the principle of provenance, see **Principle of respect des fonds/provenance** on page 6.

Understanding the provenance of a collection is central to interpreting its content and significance properly. It is important to note that the creator of a collection is not necessarily the creator of those documents. For example, a collection of letters may have many authors or creators, but the creator of the collection itself is the individual or agency who gathered them together.

To identify the provenance of a collection the archivist assembles information about the creator and the context in which the documents were created. The context for a collection's creation is defined not only by the individuals and corporate bodies that created them but also by the functions and activities that caused the documents to be created in the first place. To identify a collection's provenance it is necessary to ask:

- Who is responsible for creating the collection?
- For what purposes was it created?
- What external factors affected its creation?

This section will expand on each of these questions and suggest strategies for finding the answers.

Who is responsible for creating the collection?

The creator of the collection is the individual, family, or corporate body responsible for the production or assembly of the documents. For persons and families, information such as dates of birth and death, place of birth and domicile, variant names, ethnicity, gender, occupations, and significant accomplishments is needed. For corporate bodies, information about the functions, purpose, and history of the body, geographical location and jurisdiction of its activities, its administrative hierarchy, and earlier, variant, and successor names is needed.

Sources of information. If the creator is an individual or family, information may be found in biographical directories, family histories, published works, regional and subject encyclopedias, oral histories, and the collection itself. Business and professional directories, promotional pieces, newspaper articles, and the records themselves are sources of information about corporate bodies.

For what purposes was the collection created?
Collections are assembled around the life and activities of an individual or family, or the functions and activities of a corporate body. Understanding the activity that generated a group of documents informs us of the collection's probable content. For example, letters written to exchange news among family members are likely to contain information about social events, births, deaths, and personal commentary on contemporary events. Records created as the result of business transactions are likely to include legal and related financial records. Identifying these activities alerts us to what is likely to be found in a collection, but in no way precludes the possibility that other types of information might also be included.

Sources of information. Information about the context of a collection's creation may be found in accession records, interviews with donors, references in books about the collection's creator, and the collection itself. The identification of the types of materials found in the collection helps to determine what types of activities are documented. For example, financial daybooks indicate the existence of business transactions, while diaries suggest personal reflection and observation.

Information relating to the order and organization of documents
To review the principle of original order, see **Principle of original order** on page 6.

The principles of provenance and original order have important implications for the physical organization of collections. They suggest that the archivist must place a high value on the identification and retention of the original sequence of files and documents. This is particularly appropriate for modern organizational records. Contemporary office practices and records management principles generally result in records that come into archival custody as they were maintained in the office of origin, with the administrative structure and activities of those offices well documented.

Personal papers and older organizational records, on the other hand, are less likely to have been maintained in such an ordered way. The patterns of creation and use may not be evident many years later when the archivist acquires the collection. Under these circumstances, it becomes more difficult to establish the relationships between groups of documents.

If original order is unclear, the archivist works to reassemble it by looking for relationships among individual items and for connections among groups of items. Items with similar provenance are brought together in progressively larger groupings from the file unit to series, until the original organization is reconstructed. This process can be like sorting out the pieces of several jigsaw puzzles that have been dumped into one box. As the archivist works to reassemble the original order and structure of the collec-

tion, it can sometimes become apparent that some of the pieces are missing. Part of an archivist's education is learning how to make informed guesses about pieces of the collection that may not have survived.

If it is impossible to discern anything about original order from evidence in the collection, materials are frequently sorted first according to format or document types, then chronologically to present the documents as objectively as possible. Physically organizing documents in a collection according to a subject-based classification system such as the Dewey Decimal Classification or the Library of Congress Classification is not appropriate for archival materials. An externally imposed organization based on subject matter destroys the relationships between documents and the events to which they relate, and masks the meaning inherited from the context of their creation.

Information relating to physical extent and condition

The user needs to know how much material there is in the collection, what forms it takes, its physical condition, and any restrictions on access or use due to its condition. Methods for recording the extent vary. One method is to record the extent of textual materials in terms of the linear or cubic feet the documents occupy on the shelf; another is to record the number of items in the collection. Established institutional practices and the format of the materials themselves often determine what methods are used. The archivist also notes the presence of different types of materials such as letters, diaries, or financial records in the collection. Nontextual materials such as images or computer files are frequently recorded in terms of the number of individual items, and other units of measure are used as appropriate.

Information about scope and contents

In order for the archivist to be able to describe the contents of a collection for the user, and thus provide access, it is necessary to extract certain kinds of information from the records. The questions asked at this stage are very similar to those asked when establishing provenance; the difference lies in how the information is used.

Information about provenance comes from outside sources, as well as from the collection itself. Information about the contents of the collection itself is derived directly from the materials through content analysis; it is used to create summary descriptions to guide the user to the collection or part of a collection containing the desired information.

In order to develop summary descriptions for the user, archivists extract information about the contents of a collection by attempting to answer such questions as:

- What activities, events, and functions are documented?
- Who is involved, and what is his or her relationship to the activity, event, or function?
- What is the setting and location?
- What is the time period?
- What are the products, outcome, or consequences of the activities documented in the collection?
- What topics are addressed?
- What types of materials are included?

Content analysis

As the archivist analyzes the collection by asking the above questions, he or she must also decide whether this information is significant enough to include in a summary description. Since most collections contain too much information to be included in such a description, part of the archivist's art is determining what ought to be included or excluded. Generally speaking, archivists make their decisions in the context of the repository's mission, the significance of a particular piece of information in relationship to other information in the collection, and the historical setting in which the information was generated. The process of making these decisions is called *content analysis*, a skill which is often developed by working under the guidance of an experienced archivist.

Significance to the institution

Archival collections are acquired by institutions because their preservation contributes to the fulfillment of the institutional mission. Collections may be acquired based on the localities they document, the identity of the creator of the collection, the topics that they address, the time periods covered, or their relationship to a particular occupation, ethnic, or cultural group. Since the collection is acquired because it is significant to the institution, it is important to include this information in the collection description.

Relative significance of activities and functions documented in the collection

An archival description should include information about the principal activities and functions documented within a collection. Often the relative number of items in a collection documenting specific activities and functions will determine whether these activities and functions are recorded in the description. Some archivists suggest that if 20 percent or more of the items in a collection reflect a specific activity or function, then a description of the activity should be included in the collection's archival description.

Sometimes, however, the significance of a group of documents cannot be properly determined solely on the basis of the relative number of items documenting specific activities and functions. Consider as an

example a company's corporate records, of which over 90 percent are personnel records and sales invoices while the remaining 10 percent includes minutes of board meetings, correspondence from stockholders and directors, and financial statements. In terms of understanding the functions and activities of the company, the latter 10 percent greatly outweighs the remaining 90 percent in terms of importance, and the summary description should reflect this.

Significance of historical context

In some cases factors such as historic events, political or social movements, or ideas have an influence on the contents of a collection and/or its creators. In some cases the impact of such contextual influences is overt. The relationship between the Great Depression and the business records of a failing construction company in the early 1930s is fairly clear. In other cases, however, the influence of external forces is more subtle. For example, knowledge of the historic context in which a trade embargo threatened business helps to account for a marked change in the tone and content of correspondence between two merchants. Although the embargo was not the reason for the correspondence, and perhaps was not even a topic, it did color the content, and therefore is significant enough to be part of the archival description.

Administrative data

Some administrative details are of vital concern to the user, especially information about any restrictions on access to the records or conditions under which they may be used and cited. The long-term preservation of some personal papers and organizational records requires the archivist to recognize that they may contain materials which are, in the short run, sensitive or restricted by law. Agreements to close a collection for a period of time, or to subject them to some other conditions of access, are not uncommon, and need to be made clear to the user. Factors such as preservation considerations or remote storage might further limit access. Finally, copyright restrictions, especially when donors retain intellectual property rights, need to be noted in the archival description.

Archival Description

Description: Conveying Information to Users

The section on assembling documentation identifies the types of information about collections that the users and staff of archival repositories require, and how the archivist compiles documentation from evidence within the records, or from external sources. The work of organizing that information into a format that will be useful to the archives and its constituents results in a variety of reference tools, including catalogs and other finding aids. The catalog records and finding aids created by archivists provide a collective description of the materials in their repositories: that is, the collection as a whole is addressed through summary descriptions of its content and organizational structure rather than on an item-by-item basis. This work is known as *description.*

Descriptive Tools

Archivists today create many different types of finding aids. These may include catalog records, inventories/registers, correspondent indexes, calendars of correspondence, published repository guides, and file plans. This publication covers only the two most common types: catalog records and inventories/registers.

Catalog records
The catalog record is a tool widely employed for describing archival collections. Containing summary data about the origins, content, and physical extent of the materials, it offers the archivist a ready tool for providing simple and direct access to a large quantity of records. It enables the user to scan extensive holdings quickly. Typically, an individual record is created for each collection of personal papers or series of organizational or governmental records, in accordance with a number of standards used in the archival field. For more information, see **Descriptive Standards for Catalog Records** on page 29.

Example 1 Catalog record

	Institution:	Cupcake Corners Historical Society
	Location:	P932
Creator(s) of Collection →	**Author:**	Acme Fruit Growers Association (Excelsior, Minnesota).
Title →	**Title:**	Records, 1900–1969.
Statement of Extent →	**Description:**	4.0 cu. ft. (8 boxes, including 8 v.)
	History:	The Acme Fruit Growers Association was first organized in 1900 as a voluntary cooperative association for the marketing of fruit, and was incorporated in 1913. With metropolitan expansion taking up much of the land on which fruit had been grown, the corporation was formally dissolved in 1969.

(margin note right: Biographical Narrative/ Administrative History)

	Summary:	Correspondence, minute books, annual and financial reports, grower and customer lists, tax returns, legal documents, stock certificates, ledgers, journals, and records of fruit receipts and sales, primarily 1934–1969, of this fruit-marketing cooperative in Excelsior and Hopkins. The correspondence includes discussions of marketing problems, especially World War II sugar rationing and price controls.

(margin note right: Scope and Content Statement)

	Indexing Notes:	An inventory containing more detailed information about the contents of these records is available at the Historical Society.
	Electronic Link:	An electronic version of this inventory is available at Acme Fruit Growers Inventory.
	Subject:	Agricultural wages.
	Subject:	Cooperative marketing of farm produce--Minnesota.
	Subject:	Fruit--Cooperative marketing--Minnesota.
	Subject:	Sugar--Rationing.

(margin note right: Access Points: Topical Subject Access)

	Genre:	Corporation.
Access Points: Form and Genre Terms →	**Genre:**	Stock certificates.
	Genre:	Tax returns.

This summarizing approach is embodied in manual and electronic catalogs, in printed guides to repositories that contain brief descriptions of an institution's holdings, and in the published volumes of the *National Union Catalog of Manuscript Collections.* Summary catalog records are readily incorporated into electronic systems for online access and remote searching.

Inventories/registers

The archival inventory or register is another tool that allows archivists to deal with the quantity as well as the complex organization of archival records. It typically contains the same elements of information found in a catalog entry (origins, content, and physical extent) but with important differences. Where the catalog entry is brief, the inventory can be expansive. Contextual biographical data and administrative information can be dealt with in greater detail; the description of the scope and content of the materials may be more extensive. Likewise, the inventory/register can present the organizational structure of the records in full detail.

While the form and content of inventories/registers is largely a matter of local practice, standards are beginning to emerge. For more information, see **Descriptive Standards for Inventories/Registers** on page 31. Structurally, inventories often consist of two parts: an expanded description of the entire corpus of the materials being described (the fonds, record group, collection, or series) and a detailed list of the subordinate components of that unit. The latter usually takes the form of a container list that provides an outline of the organizational and intellectual structure of the materials, and enables the researcher to identify which storage boxes or microfilm reels might contain relevant materials.

Unlike traditional library catalog cards, inventories are free-form, narrative documents, which are very flexible as to content and presentation. Because they are typically created with standard word processing software, their production requires only a modest computer investment and is easy to integrate into office operations.

Other descriptive tools

Not all descriptive information is compiled by the local archivist. Sometimes collections come with their own documentation. Organizational and government records archivists frequently incorporate indexes, file plans, and other detailed tools generated by the creators of the records for their own access when the records were in active use. These include record and tape layouts, data dictionaries, and other documentation created by electronic record systems.

Example 2 **Inventory/register**

Acme Fruit Growers Association
An Inventory Of Its Records At The Cupcake Corners Historical Society

Access to this collection is currently restricted. For details, see the Restrictions Statement.

TABLE OF CONTENTS

Overview of the Collection
History of the Association
Scope and Contents of the Collection
Arrangement of the Collection
Organization of the Collection
Related Materials
Administrative Information
Detailed Description of the Collection

OVERVIEW OF THE COLLECTION

Creator(s) of Collection —— **Creator:** Acme Fruit Growers Association (Excelsior, Minnesota)

Title —— **Title:** Records

Date: 1900–1969

Statement of Extent —— **Quantity:** 4 cubic feet (8 boxes, including 8 v.)

Location: P932

HISTORY OF THE ASSOCIATION —— *Biographical Narrative/ Administrative History*

The Acme Fruit Growers Association was first organized in 1900 as a voluntary cooperative association for the marketing of fruit, and was incorporated in 1913. Stock was issued and each member was required to have at least one share. The Association maintained branch offices in Excelsior and Hopkins, Minnesota.

Changes in state laws governing cooperatives brought about a revision and updating of the articles of incorporation and bylaws in 1934. This was done again in 1945 when state laws were changed again.

There was a big increase in fruit growing in the years immediately following World War II, but in the decade of the 1960s metropolitan expansion had taken up so much of the land on which fruit had been grown that business decreased and the Association began to operate at a loss. The corporation was formally dissolved in 1969 and its assets sold to the Roots and Twigs Cooperative.

SCOPE AND CONTENTS OF THE COLLECTION —— *Scope and Content Statement*

Correspondence, minute books, annual and financial reports, grower and customer lists, tax returns, legal documents, stock certificates, ledgers, journals, and records of fruit receipts and sales, primarily 1934–1969, of a fruit marketing cooperative in Excelsior and Hopkins, Minnesota. The correspondence includes discussion of marketing problems, especially sugar rationing and price controls during World War II.

ARRANGEMENT OF THE COLLECTION

The arrangement of the records has followed the system originally used by the association as much as possible. The series were grouped by placing the more significant and larger series in the beginning. Although the collection was usually left in the structure it had when it came to the library, many of the folders within the series were in various states of disorder. Rearrangement of the order of these folders was often necessary in order to create a logical organization, whether it be chronological, subject, or some other arrangement. Folder titles remain intact whenever possible, except when clarification was necessary.

Statement of Arrangement

ORGANIZATION OF THE COLLECTION

These records are organized into the following sections:
Correspondence and Name Lists, 1913–1969
Minute Books: Board Meetings, 1900–1969
Accounting and Financial Records, 1932–1968
Contracts and Legal Documents, 1900–1969

Statement of Organization

RELATED MATERIALS

The manuscript holdings of the Cupcake Corners Historical Society contain a number of related collections, including the records of the Hopkins Fruit Growers Association, a contemporary competitor, and the Roots and Twigs Cooperative, which acquired much of the Acme Fruit Growers Association's physical assets.

The records of Muller, Feith, and Fruin, corporate counsel to the Association, contain extensive documentation of its legal affairs.

ADMINISTRATIVE INFORMATION

Restrictive Information

Restrictions:
Until 2015, access to the collection requires written permission. Contact the reference staff of the Cupcake Corners Historical Society for more information.

Preferred Citation:
[Indicate the cited item and/or series here.] Cupcake Corners Historical Society. See *The Chicago Manual of Style* for additional examples.

Accession Information:
Accession number: 12,467

Processing Information

Processing Information:
Processed by: William Fonds, December 1977.

DETAILED DESCRIPTION OF THE COLLECTION

Note to Researchers: To request materials, please note the box number as shown below.

Correspondence and Name Lists, 1913–1969

Arranged chronologically.

Correspondence pertains entirely to the business of the Association—the marketing of fruit raised by its members. It also discusses the problems connected with marketing, particularly during World War II, when sugar rationing and price controls resulted in substantial correspondence with government agencies. Mention is made of fruit freezing (1945) and the use of carbon dioxide to improve the shipping of fruit (1937). Earlier items are in a fragile or deteriorating condition. —— Statement of Condition

Box	Folder	Contents	—— Container List
1	1–34	Undated and 1917–1945	
2	1–20	1946–1956	
3	1–24	1957–1969	
	25–28	Name lists, 1957–1969	

Minute Books: Board Meetings, 1900–1969

Arranged chronologically.

Minute books document the Association's Board meetings and provide evidence of its management decisions. The second volume contains an amended version of the Association's Articles of Incorporation.

Box	Volume	Contents
4	1	1900–1934
	2	1934–1955
	3	1955–1969

Accounting and Financial Records, 1932–1968

Arranged chronologically by record type.

The accounting and financial records provide detailed data on daily receipts and fruit shipments. There are no accounting records prior to 1913, and very few between 1913 and 1932. A new system of bookkeeping was established in 1934, and records are quite complete thereafter. They include audit reports (1932–1961), journals (1930–1968), cash books and journals (1930–1968), and general ledgers (1916–1967).

Box	Volume	Contents
5	1–36	Audit reports, 1932–1968
	37–42	Operating statements, 1910–1934
	43–52	Annual reports, 1949–1968

Box	Volume	Contents
6	1	General ledgers, 1916–1934
	2	General ledgers, 1935–1967
7	1	Cash received journals, 1930–1943
	2	Cash received journals, 1944–1968

> **Contracts and Legal Documents, 1900–1969**
> Arranged chronologically by record type.
>
> Miscellaneous legal documents include deeds to property, articles of
> incorporation, bylaws, and dissolution papers (1900–1969). Other
> materials included within this series are annual reports to the United States
> Department of Agriculture (1949–1968), federal and state income tax
> returns (1943–1968), growers' contracts (1925–1966), and a bound
> record book listing stock certificates, valuations, and stockholders' names
> (1913–1968).
>
Box	Folder	Contents
> | 8 | 1–3 | Legal documents, undated and 1900–1969 |
> | | 4–7 | Annual reports to the USDA, 1949–1968 |
> | | 8–11 | State and Federal income tax returns, 1943–1968 |
> | | 12 | Stock certificate record book, 1913–1968. 1 volume |

Archival Information Systems: Delivering the Goods

Today catalog records and inventories/registers are the primary vehicles
used to convey information about archival collections to users. Archivists
have multiple options for deploying these tools.

Catalog records in information systems

A simple catalog entry often provides all the information the user requires.
When the collection is small (e.g., single manuscript diary) or an uncom-
plicated group of documents, such as an extensive but homogeneous series
(e.g., court dockets), the catalog record may be sufficient. Creating only
summary descriptions is a responsible approach for an institution that
cannot afford to produce more detailed public documentation. An
archival repository might also decide, as an administrative policy, to create
and make available brief descriptions of all of its holdings before proceed-
ing to more detailed documentation. This strategy is particularly helpful if
more extensive description will be deferred for some time.

While some archives continue to employ manual card files, many
now create electronic catalogs, managing their information as MAchine
Readable Cataloging (MARC) data in a local Online Public Access Catalog
(OPAC). MARC systems to create, retrieve, store, and interchange catalog
records are available for virtually every combination of computer hardware
and operating system—from desktop personal computers to large main-
frames. Often this information is distributed beyond the repository by
contributing the records to one of the national or regional bibliographic
databases such as The Research Libraries Group's RLIN database or the
Online Computer Library Center's WorldCat system. These utilities and

many vendors of local catalog software have implemented methods for making their databases searchable via the Internet using standard Web browsers.

Inventories/registers in information systems

Most institutions create some form of inventory/register, or at least a container listing, for collections that are complex or extensive. Formerly, inventories/registers were generally available only in the local repository, usually in typescript. A variety of technologies are now used to create and/or distribute inventories/registers electronically. The most universal is the use of word processors to generate print copies. Some institutions employ relational database management software to create both printed and electronically searchable finding aids.

Archivists have been quick to adopt the tools of the Internet to make their inventories/registers remotely available. At first this was done as American Standard Code for Information Interchange (ASCII) files delivered through Gopher servers, but more recently this information has been distributed as HTML markup for Web browsers. The introduction of Encoded Archival Description (EAD) has created a more structured standard for Internet delivery to remote users.

Pulling it all together: Linking catalogs and inventories/registers

The most widely employed model for search and retrieval is a two-step process. The patron first uses the catalog as a browsing device for locating potentially useful collections. Once these have been identified, the user is then directed to more detailed information found in an inventory/register. In their simplest manifestations both the catalog and inventory/register are in print form. In many repositories the catalog is now in electronic form, still directing the user to print copies of the inventory/register. Where the inventory/register and catalog record are both electronic, the connection between summary and detailed descriptions may occur seamlessly. A catalog record can be electronically connected by a hyperlink to an associated inventory/register, and both may be searched over the Internet by distant users.

Searching inventories/registers directly

With the text of inventories/registers in machine-readable form, it is also possible to search them directly, without first going through the catalog. The researcher may directly and simultaneously query the contents of a single inventory/register, all the finding aids of a single institution, or even a union database of inventories/registers from many repositories. Various search engines are available to facilitate this process, depending on whether the records are in a relational database file or encoded in HTML or the EAD. It is too early to judge the merits of this approach. Recall with overwhelming results may be a problem. Searching may prove to be a bit like trying to take a sip from a fire hose.

Standards for Archival Description

About Standards

Standards are mutually agreed upon statements that help control an action or a product. They may be created to establish consistency within an organization or among a group of organizations or countries, or be implemented globally. Archivists use standards to bring consistency to the information that they create concerning their collections.

Standards represent professional consensus on best practices

The process that produces standards typically brings together knowledgeable practitioners to codify a reasonable body of practice based on a wide range of experiences. It is important that a standard be developed through a consensus-building process in the community where it is to be used.

Standards enable and foster the interchange of information

There are standards that govern the structure and content of the information that archivists create about their collections, as well as standards that bring consistency to the way in which that information is communicated among institutions. For example, the ability to share archival catalog records widely requires the acceptance of a common interchange format such as the *USMARC Format for Bibliographic Data* (USMARC).

Standards provide an insurance policy against technological obsolescence

Archives will transfer descriptive information in electronic form to new computer systems as technology evolves. Standards facilitate that data migration.

Acceptance of standards is not without cost

Standards seldom represent the leading edge of technology. Some institutions may wish to be early implementors of new computer applications rather than wait for the standards development process. There is also a certain loss of local autonomy in adhering to standards, which was a concern, for example, when the *USMARC Format for Archives and Manuscript*

Control (USMARC-AMC) was introduced. However, today most archivists agree that the benefits of greatly enhanced access and information exchange have more than offset any negative impact from the adoption of MARC.

Different Types of Information Standards

Data structure standards

Data structure standards define the categories into which information is to be divided; they establish what data elements will be recorded. For example, it might be decided that there will be a category for name information for the corporate body or the individual around whom the collection is organized, a category for the inclusive dates of the materials in the collection, and a category for the type or format of the materials.

Data value standards

Data value standards govern the terminology that will be employed in the given categories established by the data structure standard. Thesauri, controlled vocabularies, and authority files regularize and standardize the terminology so that information about like materials will be brought together upon retrieval. A name authority file indicates which name among a number of spelling variants and pseudonyms should be used in the description.

> Example: Paul Joe Smith

> Paul J. Smith
> **Paul Joseph Smith**—(form of name chosen)
> Paul Joseph Smith Jr.

The authority file indicates which name should be used and links the others to it, so that users searching on one of the nonpreferred names will still find the record.

Data content standards

Data content standards govern the order, syntax, and form in which the data values are entered. For example, if Paul Joseph Smith is the authorized name in the authority file, the data content standard might specify that the last name be entered first, as in Smith, Paul Joseph.

Data interchange standards

Archivists also use another type of information standard, the interchange standard, which facilitates the interchange of information by specifying both a data structure and the way in which the individual data values are coded or labeled within that structure. USMARC and the EAD are both interchange standards that have these qualities. For example, the MARC format specifies that a field designated 655 be used for data on the physi-

cal form or genre of an item or group of items. The data entered there is coded according to a carefully defined protocol.

Example:

655 7_ a Accounts. |2 aat
655 7_ a Bills of sale. |2 aat
655 7_ a Correspondence. |2 aat
655 7_ a Deeds. |z Virginia |z Culpepper County. |2 aat
655 7_ a Genealogies. |2 aat
655 7_ a Wills. |z Virginia |z Culpepper County. |2 aat

Descriptive Standards for Finding Aids

Descriptive Standards for Catalog Records

Data content standards for catalog records

Several standards govern the content of catalog descriptions.

Archives, Personal Papers, and Manuscripts

Archives, Personal Papers, and Manuscripts (APPM) is the most widely
employed data content standard for the description of textual collections
in the United States. The rules outlined in APPM are intended to provide
guidance within the general context of *Anglo-American Cataloguing Rules,*
2nd edition (AACR2). Many repositories use APPM in place of Chapter 4
of AACR2, which focuses on bibliographic control rather than archival
control.

Anglo-American Cataloguing Rules, 2nd ed.

Anglo-American Cataloguing Rules (AACR2), 2nd edition, is a comprehen-
sive set of rules for the description of bibliographic materials and the
access points provided for them. Because AACR2 has focused on biblio-
graphic description, APPM and a number of other data content standards
have been developed to supplement it and to address the special require-
ments of cataloging other forms and formats of materials.

Rules for Archival Description

The Association of Canadian Archivists' *Rules for Archival Description*
(RAD) is based on the premise that all description exists in a multilevel
context. It provides a detailed set of rules that cover maps, photographs,
electronic records, and sound recordings as well as textual materials.

International Standard Archival Description—General

The International Council on Archives (ICA) has adopted the
International Standard Archival Description—General (ISAD (G)) as a
general-purpose descriptive cataloging convention. It is an enabling rather
than prescriptive standard, one intended to encompass multiple national

descriptive protocols. As such, it lacks the specificity and direction found in APPM, RAD, and other specialized protocols that govern the description of archival collections of photographs, moving images, and oral history interviews.

Graphic Materials: Rules for Describing Original Items and Historic Collections

Graphic Materials: Rules for Describing Original Items and Historic Collections provides guidelines for describing graphic/visual materials either as individual items or groups. It supplements AACR2 for those who catalog prints, photographs, drawings, and other graphic and visual items. It is accompanied by two companion publications, the *Thesaurus for Graphic Materials I* and *II.*

Oral History Cataloging Manual

The *Oral History Cataloging Manual* provides guidelines for the cataloging of oral history interviews, either as part of collections of interviews or as individual interviews.

Archival Moving Images: A Cataloging Manual

Archival Moving Images: A Cataloging Manual provides cataloging rules for the description of archival motion pictures and videotape recordings. It, like APPM and *Graphic Materials*, supplements AACR2 for these special types of materials.

Subject Cataloging Manual: Subject Headings, 5th ed.

The *Subject Cataloging Manual: Subject Headings* is a guide for assigning topical headings and subdivisions from the *Library of Congress Subject Headings* (LCSH) and provides practical guidelines for the procedures to follow.

Data value standards for catalog records

Several standards exist that govern the data values, or terminology, used in certain data categories in archival description.

Library of Congress Subject Headings

The *Library of Congress Subject Headings* (LCSH) is a comprehensive list of the headings used by the Library of Congress and thousands of libraries and archives. LCSH provides topical headings that describe the content or subjects of books and archival materials.

Art & Architecture Thesaurus

The *Art & Architecture Thesaurus* (AAT) provides vocabulary for the description of archival materials. It can be used as a source of topical, form and genre, occupation, and function terms, and also provides terminology

to describe the materials of which items are made, and the processes and techniques of their making.

Thesaurus for Graphic Materials

The *Thesaurus for Graphic Materials* has two parts. The first, *Subject Terms* (TGM1), is a source for topical terms for graphic materials, based on LCSH headings; the other, *Genre and Physical Characteristic Terms* (TGM2), provides terminology for the description of the form and genre of these types of materials.

Library of Congress Name Authority File

The *Library of Congress Name Authority File* (NAF) enumerates the preferred form of hundreds of thousands of personal and corporate names. The file contains links to alternative and variant forms of names, as well as pseudonyms, to guide the user to the authorized form of a name.

Union List of Artist Names

The *Union List of Artist Names* (ULAN) serves as a source of authority data for the names of artists and architects. Alternatives, spelling variants, nicknames, and pseudonyms for an individual are clustered so that a pre-ferred form may be chosen. Entries also include biographical data (e.g., life dates, role) and bibliographic citations referring to the artist.

Getty Thesaurus of Geographic Names

The *Getty Thesaurus of Geographic Names* (TGN) provides a hierarchically structured listing of geographic names worldwide, including historical names, linked to their modern equivalents.

Data interchange standards for catalog records

The *USMARC Format for Bibliographic Data* is a widely used interchange standard employed by many archives. It specifies multiple categories of information that are used to describe bibliographic and archival materials, as well as other formats. In this capacity it functions as a data structure standard. The individual data values entered into the fields receive a variety of codes that specify additional information.

Descriptive Standards for Inventories/Registers

Data content and data structure standards for inventories/registers

While the contents and structure of inventories/registers remains largely a matter of local practice, recent analysis has demonstrated considerable similarity in the practices of many repositories as institutions have adopted models developed by the Library of Congress and the National Archives of the United States. Several content standards are emerging. The Canadian

Rules for Archival Description (RAD), focused on multilevel description, has been suggested as a possible data content standard for inventories/ registers. The EAD, with its companion *Application Guidelines*, is another option under development.

There is, of course, significant overlap between the content found in catalog entries and that found in inventories/registers. The latter contain the same types of information as the former, though expanded. This information includes creator, title, dates, physical extent, scope and contents, administrative or biographical data, and administrative information on access, restrictions, and similar matters.

Data value standards for inventories/registers

No explicit standards governing data values are applied to inventories at this time. Insofar as key data elements in an inventory/register mirror the information found in a catalog entry, the standards that apply to the latter may be used in the former. Where such standards have been applied in an inventory, e.g., the name of the creator of the collection has been formed according to AACR2 standards, the EAD encoding scheme provides a mechanism both for noting the standard used to construct the term and for citing the relevant authority file entry.

Data interchange standards for inventories/registers

The only interchange format that currently exists for inventories/registers is the EAD, a data structure and data interchange standard that defines the structural elements of archival inventories and their interrelationships. For example, it provides a method for encoding the text of an inventory/register so that one could specify that a particular piece of information is the title of a file, and that this file is part of a particular series.

The EAD standard is written in the syntax of a Standard Generalized Markup Language (SGML) Document Type Definition (DTD). Version 1.0 of the EAD is also compliant with Extensible Markup Language (XML). The EAD is the intellectual property of the Society of American Archivists through its international EAD Working Group. The Library of Congress serves as the maintenance agency for the EAD. More information about the standard and related documentation may be found at http://lcweb.loc.gov/ead.

Part III Putting It All Together: How an Archivist Works

Archival Processing

What Is Processing?

To make a collection accessible for research, the archivist must gather and analyze information about the collection, physically organize and arrange the materials into a useful order, and create appropriate finding aids so that the user can identify and locate relevant materials. *Processing* is a comprehensive term encompassing all the work needed to make collections useable and available for research. There are three distinct activities in processing a collection:

- Gathering and analyzing information about the collection
- Organizing and arranging the collection
- Creating finding aids to provide access to the collection

In practice, processing a collection is a set of repetitive and iterative operations, rather than the discrete sequential steps shown above.

Gathering and Analyzing Information

Archival materials are seldom acquired in pristine order with detailed documentation of their origins, internal structure, subject matter, and historical significance. In order to physically organize the materials properly and to assemble the documentation necessary to create appropriate finding aids, the archivist must consult a variety of external sources and carefully study the contents of the collection itself. This work is suffused with, and informed by, a continual process of gathering information about the materials, analyzing it, and applying it to their organization and description. For more information about gathering and analyzing information, see **Assembling Documentation** on page 12.

Review information in existing accession records or other transmittal documents such as donor agreements, transfer forms, records retention schedules, and disposal authorizations.

Accession information includes:

- The donor's name and address
- The collection's name
- The date the institution received the collection
- Whether the collection was acquired by donation, transfer, or purchase
- How the collection fits into the institution's collection policy
- Information the donor provides about the contents of the collection and the people and organizations documented therein

Conduct research in reference sources

The archivist also checks external reference sources for additional information about the creators of the materials being processed, to better recognize and understand the contents and interrelationships of individual documents. Useful sources of information include local or regional histories, biographical dictionaries, other related archival collections, city directories, cemetery records, and various types of reference works. Such resources may be revisited during processing as information about new persons, places, and events is encountered in the documents.

Study the contents of the collection

During the process of organizing the documents, the archivist will gather additional data about their provenance, the activities and functions they document, their physical composition and arrangement, their subject content, and their historical significance. For more information about the types of information collected, see **What Information is Collected?** on page 12, through **Significance of historical context** on page 17.

Organization and Arrangement

The task of physically putting materials in a collection into a particular order involves two closely related activities: organizing and arranging. Archivists generally refer to *organizing* as the activity of dividing the collection into distinct units, such as series and subseries. Once these units have been established, *arrangement* refers to the filing pattern, such as alphabetical or chronological order, that the materials will follow.

As the archivist examines the collection, he or she gathers information about its structure. At the same time, he or she analyzes the content of the collection, which may in turn inform the final organization and arrangement.

The physical processing of collections includes four related activities:

- Organizing
- Arranging
- Housing
- Conserving

These may be performed as distinct and separate actions that are fully completed one after another in sequence or, as is more often the case, carried out in a nonlinear process, moving back and forth between the different activities as the collection is examined.

Organization

Organization relates to the manner in which the materials have been subdivided into smaller units: as, for example, record groups being divided into series, and series into subseries. It is the underlying conceptual order of the collection. As the archivist examines the collection, the order and organization is noted, as is information about the type of material, information recorded therein, and people, events, and activities documented. The manner in which items are grouped and organized can reveal new information that assists in the understanding and interpretation of the collection. All of this information is brought to bear on how the collection is ultimately organized and arranged. Following the principle of original order, the archivist tries to retain as much of the original organization as possible, reorganizing parts or the whole only when access is hampered, or the materials are rendered unusable by their current organizational scheme.

Arrangement

Arrangement relates to the pattern of filing (e.g., alphabetical, chronological, etc.) of materials within the unit described. Once the organizational relationships among the various units and sub-units of the collection have been established, the archivist decides how to order the individual items within those units.

Housing

Determining the proper size and type of container for different materials is another task performed at this time. Size, condition, and format are all factors in deciding upon what type of container is appropriate. Repackaging the materials into archivally appropriate acid-free boxes

and folders is another important component of the physical processing of a collection.

Conservation

Making decisions about which materials should receive special conservation treatment occurs at this stage, which might also include such activities as removing metallic fasteners, and copying fragile and brittle items (including newspapers and thermofax documents) to save wear and tear on the originals.

Creating Descriptions in the Form of Catalog Records and Inventories/Registers

The descriptive tools, or finding aids, that are created to provide intellectual access are also based on the archivist's analysis. Catalog records and inventories are the primary vehicles used today to convey information about archival collections to users.

The creation of finding aids, both catalog records and inventories/registers, is a complex process that requires the archivist to have a working knowledge of the standards and tools (see **Descriptive Standards for Catalog Records** on page 29, and **Descriptive Standards for Inventories/Registers** on page 31), and to acquire cataloging skills that go far beyond the scope of this publication.

The creation of a finding aid requires many decisions that draw upon the archivist's knowledge of the collection and understanding of descriptive principles. For example, there may be a number of ways to record information properly in each of the areas of a catalog record (e.g., title, date), depending on the type of collection being described. APPM sets out the rules governing these decisions, and archivists should be thoroughly familiar with this accepted standard before creating catalog records. As part of its Descriptive Standards Institute, the Society of American Archivists (SAA) offers a two-day workshop, *Cataloging as a Component of Description*, which gives beginning archivists a thorough grounding in the needed skills.

While there may still be some variation among institutions as to the format of catalog records, the MARC format is the most widely accepted standard for these and is, indeed, mandatory for institutions contributing records to the bibliographic utilities. While the subtleties of MARC cataloging may be learned through on-the-job practice, formal training is preferable for acquiring the basics. SAA's workshop *Application of the USMARC Format* is a good place for the novice to begin orientation to the intricacies of MARC. More long-range instruction can be obtained in formal cataloging courses.

While there is widely accepted standardization of catalog records through the use of MARC, no such standard existed for inventories/registers until the emergence of the EAD for electronic finding aids. Creating finding aids using the EAD requires an understanding of the EAD DTD and SGML authoring software. The SAA workshop *Encoded Archival Description* has proven to be a very popular venue for this training, having been presented widely in the United States, as well as in Europe and Australia.

Use of various standards governing access points in finding aids, such as LCSH and the AAT, also requires some more formal instruction. While the *Subject Cataloging Manual* lays out rules for forming LCSH headings, and the AAT Application Protocol does the same for AAT terminology, it is recommended that beginning archivists seek out more structured training opportunities, where they can practice using these tools. The Descriptive Standards Institute's two-day *Access Points* workshop provides such a venue, as do cataloging courses in formal graduate programs.

The reader is also encouraged to consult the bibliography in this publication for more detailed information concerning the creation of finding aids.

Part IV What's Ahead in Description and Access

The Future

The methods and tools of description are continually evolving, driven in part by the need to document new forms of recordkeeping, especially electronic data. Current techniques and descriptive instruments are clearly inadequate for documenting transactions carried out on computers. Archivists must learn how to incorporate system-generated descriptions of their collections into the larger framework of archival descriptive systems for documentation and retrieval.

The other compelling force affecting archivists is the environment in which they document their collections. Increasingly, this is an electronic world of remote access by distant users working without direct staff mediation. Many archival institutions are challenged to broaden their clientele, to reach out to students and other constituencies who may be less familiar with archives and the use of primary resources. More and more, archivists are being asked to deliver electronically not only the descriptive information about their collections, but also the documents themselves. Issues relating to access, presentation, and navigation of collections are affecting policy and practice as much as more theoretical concerns about provenance and respect des fonds.

Better tools must be developed to enable seamless searching and navigation across a complex information space containing catalog records, inventories/registers, and original documents, and also to facilitate the display of the results in a comprehensible way. Current Internet search and retrieval systems do not appear to be up to the task; they are better suited to an environment of homogeneous data. There are other possibilities. The ANSI Z39.50 standard enables controlled search and retrieval across diverse databases including MARC records, full-text files, and eventually archival inventories/registers. This standard is what makes such integration possible. Perhaps extensions to the HTML and SGML markup languages will be the vehicle for disseminating both descriptive metadata and digital collections in the future.

Certainly the differences between summary and detailed descriptions, between catalog records and inventories/registers, will become less distinct and significant. The two types of description may even merge. In the past, they were distinguished by differences in appearance and depth of detail. For the past ten years, there has been the additional distinction that catalog records have been widely available as MARC records but inventories/registers could be searched only locally. As inventories/registers become available on the Web, the differences between them and electronic catalog records will blur even further.

Will the electronically encoded inventory/register replace the summary MARC record? The answer will become clearer as more sophisticated search engines are developed and the EAD is employed more widely. However, MARC records will remain viable for a long time to come; they are still the most widely used, standards-based tool for information interchange. Archivists will continue to need to contribute information about their holdings to local and international online catalogs. Users will continue to want concise summaries as they quickly scan large bodies of archival documentation.

A blending of summary and detailed information into a new descriptive tool would certainly simplify both the descriptive and searching processes. No longer would catalogs and inventories/registers be distinctive products, created separately. Rather, the user would simply encounter different presentations of the same underlying data, either a summary overview of the whole or a detailed documentation of some component. This accomplishment will require the development of a new descriptive standard, one that focuses on content and not the format of its presentation to users.

Tutorial: An over-the-shoulder view of an archivist at work

Introduction

The best way for a novice to understand the theoretical underpinnings of arranging and describing a collection is to watch someone perform the various necessary tasks. Under the guidance of an archivist the novice can ask questions and even do some processing. You now have the chance to be an apprentice and look "over the shoulder" of an archivist in a step-by-step review of the tasks involved in organizing and describing a collection. If you haven't already, please read **What Is Processing?** on page 34.

Memorandum
To: Archivist
From: Director
Re: Next collection to process
 In reviewing the list of collections waiting to be processed, I noticed one coming from the building at 101 Main St. in Charleston, SC, that contains land surveys. I would like you to process this collection next. Also, I have assigned an archival trainee to you as you organize and describe the collection, so please explain not only what you are doing, but why.

STEP 1: Preliminary work on the collection: Gathering information

Review information in existing accession records or other transmittal documents such as donor agreements, transfer forms, records retention schedules, and disposal authorizations. It may be necessary to move back and forth between these sources to compile background information needed for further analysis of the materials. To review the overview of this step, see **Review information in existing accession records** . . . on page 35.

The archivist discovers the following information from the accession records. The collection was given by George Maybank in 1995 and came from the top floor of a building at 101 Main Street. Maybank, who was renovating the space to make more offices, brought the materials to the archives in five irregularly sized whiskey boxes. The gift form shows that the collection includes documents and land surveys ranging in date from the 1890s to the 1930s. Also in the accession records is a statement from the donor that as he went through the papers looking for stamps, he found some documents dating from before the Civil War. This fact alerts the archivist to be on the lookout for the possibility that some documents might be older than the gift form indicates.

Research in sources external to the collection. To review the overview of this step, see **Conduct research in reference sources** on page 35.

Since the donor did not know who created the records, the archivist seeks clues to whose documents these were by asking the question: Who were the tenants of the building at 101 Main Street between the 1890s and 1930s? City directories listing building occupants by street address may provide an answer. There is not a complete run of city directories for the period in question, but there are enough to identify a surveyor, S. Lewis Jervey, who leased the building at 101 Main Street in 1905 and again between 1910 and 1932. The archivist then consults the institution's donation forms, reference files, and other collections to see if there is additional information on Jervey

there. Since none is found, it is necessary to turn to the collection itself for more clues.

Conduct a preliminary review of the collection materials. To review the overview of this step, see **Study the contents of the collection** on page 35.

The archivist makes a preliminary survey of the boxes to see what is in them. The first box contains many small notebooks, while the second and third contain personal and business letters, either addressed to S. Lewis Jervey or written by him. So far, the evidence suggests that this collection was created by Jervey. The next box, containing receipts for work done by him, strengthens the archivist's confidence in this hypothesis. The last of the five boxes contains copies of plats with Jervey's signature on them. At this point in the inspection, the collection appears to be Jervey's records. If this is the case, there are still a few factors that don't quite fit, which stirs the archivist's curiosity. The pre-Civil War materials mentioned by the donor have not appeared. Also, the first box contained notebooks, but Jervey's name didn't appear on those sampled. Whose are these?

Research in sources external to the collection. To review the overview of this step, see **Conduct research in reference sources** on page 35.

With this question in mind, the archivist goes back to the box of small notebooks for a closer look. The name on the front of the first one is John A. Mitchell. The name sounds familiar to the archivist, who decides to check the catalog to see whether there is information on Mitchell there. The hunch pays off. Mitchell was a surveyor who did a great deal of work in the city, and the archives holds papers pertaining to work he did after the Civil War.

Preliminary review of collection materials. To review the overview of this step, see **Study the contents of the collection** on page 35.

Having discovered this important link between the Mitchell holdings in the archives and the collection being processed, the archivist returns to the first box. The cover of the next notebook reveals that these are copies made by Mitchell of books originally generated by Charles Parker. The cover reads: "Copied by John A. Mitchell Jan. '61 from Charles Parker's notebooks." Who was Charles Parker?

Research in sources external to the collection. To review the overview of this step, see **Conduct research in reference sources**, on page 35.

The archivist makes another trip to the catalog and reference files to see if there is information on Parker. This search turns up nothing. The archivist next consults the local tombstone index and learns that a Charles Parker died in 1859. No further information is readily available, so the next hope is that there will be more information about Parker in the collection itself.

Preliminary review of collection materials. To review the overview of this step, see **Study the contents of the collection** on page 35.

The next notebook contains a note that it was copied by John A. Mitchell in 1861. The next two are also copies and are numbered "4" and "5." These seem to form a series of notebooks of Charles Parker's original notes. There is also a notebook with plats for Charleston in 1817. The archivist makes note of the fact that this collection will be a wonderful resource for people researching the early built environment of the city. The question of how the copies of Parker's notebooks ended up with Jervey's papers still remains, however. The best guess is that Mitchell was a surveyor who either knew Parker or took over Parker's business, or the notebooks could have been stored in the building prior to Jervey's occupancy. To check this last hypothesis, the archivist returns to the city directories to see if

either Mitchell or Parker had a connection to the building at 101 Main Street. Finding no evidence that either had worked or lived in the building, the archivist concludes that there may be another type of link between Jervey's papers and the copies of Parker notebooks. It seems appropriate to treat them as different parts of the same collection, and to remain alert for clues about ties between Jervey and Mitchell.

STEP 2. Part 1: Organization and arrangement

Analysis of the collection's organization and arrangement. To review the overview of this step, see **Organization and Arrangement** on page 35.

There is no discernible order to Jervey's papers. The letters are from many different sources, with several groups of letters from different architectural firms in Charleston. The question is now: How should Jervey's papers be arranged?

Plats

The plats are of different sizes and cannot be stored in letter-size or legal-size folders. Based on their physical size, the archivist creates a separate series for plats within the Jervey papers. This decision requires that different sizes of storage containers be used for the materials.

While working with these materials, the archivist notices that some have sustained water damage and that mildew has caused some of the sheets to stick together. These damaged items should be sent to a conservator to be cleaned and stabilized before they are refiled with the rest of the collection.

Should the letters and receipts be filed together?

This leaves the letters and receipts to be considered, and raises the question of whether these should be grouped together or separately. One approach is to put everything found in a collection in chronological order. Another is to separate items according to material types, then arrange them chronologically, a practice this institution usually follows. If this is done, the letters and receipts would each be treated as a separate series. Before proceeding with this step, however, the archivist checks to make sure that the receipts are not enclosures for the letters, which would establish a close link between the types of materials. Since no such relationship is found, the separate series are created.

The size of the Jervey collection is also a factor in this decision. The quantity of letters and receipts warrants a separate series. Had the collection consisted of only a few items, it would not have been necessary to do this. While it is valuable for an institution to have standard procedures for arranging collections, there are always cases when a different solution is warranted. Here the archivist must exercise judgment about what arrangement makes the materials most easily accessible.

Receipts

With separate series established for the letters and receipts, the archivist now turns to the arrangement of the receipts. If the original filing order had remained intact, it would have been maintained, and any loose receipts would have been inserted into the existing filing system. In this case, the original order of the receipts is not evident,

so the institution's practice of arranging the items chronologically is followed.

Letters

The next series to consider is Jervey's letters, which do not appear to be arranged in any particular order. The groups of letters from Charleston architectural firms do not seem to be in any order, either. It is possible that the letters were originally filed either by correspondent or by project. The archivist reads through the letters looking for evidence of this type of arrangement without disturbing the current order of the letters. Some letters are grouped by project, but there are also letters concerning these same projects scattered throughout the collection. In addition, there are a considerable number of letters about similar projects unrelated to those mentioned in the grouped letters.

Since there simply is not enough information to establish that the letters were originally sorted by project, the archivist decides to arrange the letters chronologically. Arranging the items in this manner will provide a consistent framework for researchers to locate them in the series, and it will be easier for researchers to cross-check between the receipts series and the letters series for related information.

Notebooks

The first notebook that the archivist examines is numbered "4" and contains a note that it was copied by John A. Mitchell in 1861. The next notebook is numbered "5." These seem to form a series of notebooks based on Charles Parker's original notes.

Notebooks: Conservation and storage

Before the notebooks can be put back in sequence, it is necessary to note the physical condition of the documents. The covers of the notebooks feel very gritty. The archivist carefully cleans the covers by brushing them off with a soft-bristle brush, brushing from the middle out to the edges to avoid just moving the dirt around on the covers. Notebook number 54 is in very fragile condition. It will be necessary to microfilm it so that researchers can have access to the information without handling the book itself. Perhaps it could be photocopied while waiting for microfilming to be done. Once the books have been cleaned and the condition noted, they can be put in order.

Notebooks: Organization

Putting the books in order reveals that there are 136 notebooks, sequentially numbered, containing copies of Charles Parker's original notes. There are also 24 notebooks that S. Lewis Jervey used to record rough sketches of plats. The 24 notebooks will become a series in the collection of papers generated by Jervey.

The final collection outline

After systematically going through the Jervey papers the archivist has organized them into two main series, further subdivided into subseries:
1. Papers generated by Jervey
 - Letters (arranged chronologically)
 - Receipts (arranged chronologically)

- Notebooks by S. Lewis Jervey (arranged sequentially)
- Plats (arranged chronologically)

2. Mitchell's copies of Parker's notebooks (arranged sequentially)

STEP 2. Part 2: Content analysis

Analysis of scope and content of the collection. What is the relevance of the collection to the institutional mission? To review the overview of this step, see **Content analysis** on page 16.

The accession records indicate that the new collection was acquired because of its detailed plats of poorly documented areas of Charleston. In the past, the archives has been very careful to reference in its finding aids information that would help preservationists document the built environment. It will be important to bring out this fact in the final description. To be consistent with what has been done in the past, the archivist will need to be on the lookout for references to any buildings or extraordinary details concerning construction.

Analysis of scope and content of the collection. What historical context is relevant to collection content? To review the overview of this step, see **Significance of historical context** on page 17.

The archivist checks sources to find out what was happening in the city during Parker's time. It is noted that there was a hurricane in 1821 and a fire in 1838 that devastated a neighborhood at the city limits. The area north of Calhoun Street was not incorporated into the city limits until 1848. Flooding was a constant problem, and civic leaders sought to control it during this period.

The archivist focuses first on Mitchell's copies of Parker's notebooks around the time of the Civil War. It has already been established that the earliest of Charles Parker's notes date from 1813 and the latest from 1858. The archivist recalls that in first sorting the books of Parker's notes and plats, it appeared that the plats were for areas of Charleston that were relatively new in the nineteenth century. Also included are memoranda for work done for different individuals. It is not known why the notebooks were created, nor is it clear how and why they ended up in Jervey's papers. Since there is no further information about Mitchell or Parker in reference sources, the answers to the following questions will have to come from the materials themselves.

- Who was Charles Parker?
- Clearly he was a surveyor, but for whom did he work?
- Did his work focus on any specific areas of Charleston?
- Did he record anything not directly related to his work?
- What is the relationship among Parker, Mitchell, and Jervey?

The archivist is now prepared to read the notebooks more closely. As this work progresses, the archivist records information that seems important. The difficulty is finding a balance between recording too much information, which is counterproductive, and omitting something that may be found to be important later on. It is necessary to record enough information so that the type of activities documented in the notebooks is made apparent, thus allowing researchers to decide whether they are relevant to their research needs.

With this in mind, the archivist turns to the first notebook for closer examination. On the first page is a detailed plat for an area on the neck of Charleston's peninsula with property lines and footprints of houses, including such details as the location of windows, porches, and external stairs.

As the archivist examines subsequent notebooks, notes of work done for different clients (among them the city of Charleston itself) are found. One entry appears to be a bill with Parker's name and a title beneath it in small script. Examination of the title with a magnifying glass reveals that he was the city surveyor, which explains a great deal about the collection. Knowing that Parker was the surveyor for the city is an important clue to the provenance of the collection. The archivist goes to antebellum city ordinances to determine whether there is information about the duties of this office. Among the 1838 city ordinances is a position description stating that the city surveyor was responsible for surveying streets, gutters, and other public infrastructure as well as for general survey work. This information will be helpful in understanding and analyzing the materials.

During the initial review of the collection, the archivist had noticed columns of numbers next to street names. Now the purpose of these is revealed by a caption at the top of one list, which reads, "Number of bricks needed from Messr. Horlbeck." Clearly, Parker was measuring the number of bricks needed to pave various streets, and Horlbeck, a prominent Charleston businessman, whose papers are also in the archives, was furnishing the bricks. The archivist decides that it will be necessary to check the Horlbeck collection to see whether there is further reference to this work.

The notebooks also contain entries for different clients. Evidently, Parker was working for the city and also working as an independent surveyor for James Petigru, James Tupper, Otis Mills, and the estate of Elias Smith. Plats showing high-tide levels in areas of the city still prone to flooding are also found. One shows the City Market with flood levels similar to those recorded during recent heavy rains. Another plat shows flood levels on Water Street. There is a sketch labeled "canal," which puzzles the archivist momentarily, since there are no canals in this part of Charleston. Further research shows it to be a canal to drain the flooding caused by high tides. The notebook also reveals directions for mixing mortar to withstand salt water as well as formulas for mortar for house construction. The archivist, knowing that local preservationists have inquired about such information, makes note of this item.

Parker also surveyed properties throughout the city, but most frequently he worked in those sections that were new in the antebellum period. He also did a considerable amount of survey work in the area north of Calhoun Street, after it was annexed to the city. Contrary to the archivist's expectations, there was no evidence in the notebooks of the 1838 fire or the 1821 hurricane.

Analysis of scope and content of the collection. What activities are documented in the collection? To review the overview of this step, see **Relative significance of activities . . .** on page 16.

The archivist examines all 136 notebooks, making notes about their contents. The predominant activities reflected in them are the survey work for the city and private clients, calculation of numbers of bricks

needed for city streets, and planning of canals to drain areas flooded by high tides. Throughout the notebooks are directions for mixing mortar, primarily for drainage canals.

STEP 3: Create descriptions in the form of catalog records and finding aids

Create descriptions in the form of catalog records and finding aids. To review the overview of this step, see **Descriptive Tools** on page 18.

The archivist now takes the detailed notes recorded while working with the collection and creates a register to describe its organization, arrangement, contents, and context. Researchers will use this information to identify whether the collection contains information relevant to their research needs and where in the collection it is located. The archivist will then write a summary of the description in the finding aid to be used to create a catalog record for the collection. Below is a series-level catalog record for the part of the collection analyzed in the tutorial:

Sample catalog record

Mitchell, John A.
Copies of Charles Parker's notebooks, ca. 1860s.
136 v.

 Charleston, SC, surveyor. Mitchell made copies of Charles Parker's notebook prior to the Civil War. Parker was surveyor for the city of Charleston, SC, from 1817 until his death in 1859.

 Copies of Charles Parker's notebooks contain plats of the city of Charleston, SC, and related notes and memoranda pertaining to surveys made by Parker as city surveyor and as an independent surveyor for clients such as James Petigru, James Tupper, Otis Mills, and the estate of Elias Smith. Notes and plats include details such as property lines, the locations of features such as windows, porches, and external stairs on buildings, amounts of bricks purchased from "Messr. Horlbeck" for the paving of city streets, and directions for mixing different types of mortars. Most plats are of newer sections of nineteenth-century Charleston, and many pertain to areas of the city prone to flooding, showing high-tide levels and the location of drainage canals.

Glossary

When the glossary definition has been taken from another source, the source is noted in parentheses after the entry. A key to abbreviations is at the end of the glossary.

access point
A name, keyword, index term, etc. by which a description may be searched, identified, and retrieved. (ISAD(G) Glossary)

accession records
Records documenting additions to a collection, whether acquired by transfer under a legally based procedure, or by deposit, purchase, gift, or bequest. (ICA) Donor agreements, transfer forms, record retention schedules, and disposal authorizations are all types of accession records.

acquisition information
Information about the source of the materials being described and the circumstances of the acquisition. (EAD Tag Library)

administrative history
see **biographical narrative/administrative history**

arrangement
The filing pattern (e.g., alphabetical, chronological, etc.) of materials within the unit described. Distinguished from "organization," which relates to how materials have been subdivided into distinct units, such as series into subseries.

ASCII
American Standard Code for Information Interchange is the standard that designates a code for representing alphanumeric information (letters, numbers, and punctuation) in computers.

authority file
Documentation of the authorized form of names or subject headings used in a catalog, inventory, or information retrieval system. (AAT)

bibliographic utility
A provider of bibliographic services such as a union catalog for centralized searching, shared cataloging, and collection resource sharing.

biographical narrative/administrative history
Essay or chronology providing biographical or historical information about the individuals, family, or corporate body responsible for creating or assembling the materials being described. (EAD Tag Library)

catalog record
A descriptive tool used to provide, at a summary level, information about the origins, content, and physical extent of materials. For more information, see **Catalog records in information systems** on page 24, and **Example 1. Catalog record** on page 19.

conservation information
Information about the processes relating to the conservation of materials, including assessment, treatment, and use data.

container list
A type of finding aid that provides an outline of the organizational and intellectual structure of the materials, and enables the researcher to identify which storage boxes or microfilm reels might contain relevant materials.

content analysis
The process of analyzing the content of a collection in order to determine what information is significant enough to be included in a summary description. For more information, see **Content analysis** on page 16.

corporate records
Records generated by a corporate body or organization or group that are the direct result of administrative or organizational activity of the originating body. (Adapted from APPM 1.0A)

data dictionary
A document specifying what information is to be entered into designated fields of a database, and sometimes prescribing rules governing form and order of entry.

description
The process of compiling and organizing information that has been extracted from the collection or gathered from external sources into a form that will be useful for the user. Description also refers to the physical tool that is the result of the descriptive process, often a catalog record or finding aid. For more information, see **Description: Conveying Information to Users** on page 18.

documentation
A broad range of activities that archivists undertake in order to create descriptive tools that facilitate user discovery, establish the authenticity of their holdings, and satisfy various administrative needs. For more information, see **What Is Documentation?** on page 2.

EAD
Encoded Archival Description is a standard for the encoding of electronic versions of archival inventories and registers. It defines the structural elements of a finding aid and their interrelationships. In short, the EAD does for archival inventories and registers what MARC does for catalog records. The EAD standard is embodied in a Document Type Definition (DTD) that conforms to the syntax of Standard Generalized Markup Language. For more information, see **SGML**.

finding aid
The broadest term to cover any description or means of reference made or received by an archives in the course of establishing administrative or intellectual control over archival material. (ISAD(G) Glossary) These are variously characterized as inventories, registers, and container lists. Some

archivists consider catalog records a form of finding aid. For more information, see **Inventories/registers in information systems** on page 25, and **Example 2. Inventory/register** on page 21.

fonds

The whole of the documents, regardless of form or medium, organically created and/or accumulated and used by a particular person, family, or corporate body in the course of that creator's activities and functions. (ISAD(G) Glossary) For more information, see **Principle of respect des fonds/ provenance** on page 6.

HTML

HyperText Markup Language is a coding language that allows designated words or blocks of text to be linked to other sections of the same document or to other files on the Internet. HTML is used to create hypertext documents for the World Wide Web.

inventories
see **finding aid**

location information

The physical or logical location of the materials being described. (EAD Tag Library)

MARC
see **USMARC**

multilevel description

The preparation of descriptions that are related to one another in a part-to-whole relationship and that need complete identification of both the parts and the comprehensive whole, by means of multiple descriptive records. (RAD Glossary)

name authority file

A list of the authorized form of personal, geographic, or corporate names to be used in a catalog, inventory, or information system.

OPAC

The Online Public Access Catalog is the public interface through which an archive's users search for the materials they desire. The information made available to the patron

varies from institution to institution, but this is where the public makes use of the descriptive documentation that the archivist has created for the repository's holdings.

organization

The manner in which materials have been subdivided into smaller units, such as record groups divided into series, and series into subseries. Distinguished from "arrangement," which relates to the filing pattern (e.g., alphabetical, chronological, etc.) of materials within the unit described.

original order

The archival principle asserting the importance of retaining the order and arrangement of the materials in the collection as they were originally organized, in order to preserve evidence about how they were created. For more information, see **Principle of original order** on page 6.

personal papers

The private documents of an individual or family. Documents might include correspondence, financial records, photographs, ephemera, etc. (Adapted from Duckett, *Modern Manuscripts*)

processing

Gathering information about a collection, physically organizing and arranging the materials, and providing access through description. For more information, see **What Is Processing?** on page 34.

provenance
see also **respect des fonds**

The persons, families, or corporate bodies that created and/or accumulated and used records, in the conduct of personal or business life. An understanding of the context in which a collection was created, including the individuals who created the materials, the activities and functions that generated them, and the events surrounding their creation, is central to the interpretation of materials in archival collections. In some contexts prove-

nance is regarded as custodial history. For more information, see **Principle of respect des fonds/provenance** on page 6.

record group

A body of organizationally related archives or records established on the basis of provenance with particular regard for the administrative history, the complexity, and the volume of the records and archives of the institution or organization involved. (APPM 1.0A)

registers
see **finding aid**

respect des fonds
see also **provenance**

The persons, families, or corporate bodies that created and/or accumulated and used records, in the conduct of personal or business life. An understanding of the context in which a collection was created, including the individuals who created the materials, the activities and functions that generated them, and the events surrounding their creation, is central to the interpretation of materials in archival collections. For more information, see **principle of respect des fonds/provenance** on page 6.

restriction information

Information about either of two types of restrictions: on access and on use. Access restrictions govern physical access to the materials. They may be imposed by the repository, donor, legal statute, or government agency. Use restrictions govern what may be done with the materials after access has been granted, such as restrictions on reproduction, publication, and citation.

scope and content statement

Essay or abstract summarizing information about the scope and content of the materials being described, including the form and arrangement of the material and the names of organizations, individuals, events, places, and topics documented therein. (EAD Tag Library)

series

Documents arranged in accordance with a filing system or maintained as a unit because they result from the same accumulation or filing process, or the same activity; have a particular form; or because of some other relationship arising out of their creation, receipt, or use. A series is also known as a records series. (ISAD(G) Glossary) For more information, see **Individual items in a collection . . .** on page 8.

SGML

Standard Generalized Markup Language is an international standard for the development of protocols for the electronic encoding of text. SGML specifices the general syntax and notation for specific encoding schemes called Document Type Definitions (DTD). A DTD defines the common structural elements of a given class of documents (e.g., archival finding aids, literary texts, exhibition catalogs) and specifies the relationships among them.

statement of arrangement

Information on the arrangement of the materials, such as the principal characteristics of the internal structure, the physical or logical ordering or filing sequence of materials, and how materials have been treated by the archivists. (EAD Tag Library)

statement of condition

Description of the physical condition of the materials.

statement of extent

The quantity of materials, expressed as an item count, space occupied, or number of containers (boxes, drawers, folders) occupied.

statement of organization

Information on the organization of the materials, such as the logical and physical hierarchical groupings into which they have been arranged. (EAD Tag Library)

subject authority file

A list of the authorized subject/topical heading used in a catalog, inventory, or information retrieval system.

title

A word, phrase, character, or group of characters that names a unit of description. (ISAD(G) Glossary)

USMARC

USMARC, commonly referred to as MARC, stands for MAchine Readable Cataloging, a widely used communication standard for the interchange of archival and bibliographic information.

Z39.50

Z39.50 is an information retrieval protocol that supports communication among different information systems, making it possible for a user to search various systems without knowing the different search syntaxes employed.

Abbreviations used for sources

AAT

Art & Architecture Thesaurus. 2nd ed. New York: Oxford University Press, 1994. http://www.gii.getty.edu/aat_browser/

APPM

Hensen, Steven. *Archives, Personal Papers, and Manuscripts: A Cataloging Manual for Archival Repositories, Historical Societies, and Manuscript Libraries.* 2nd ed. Chicago: Society of American Archivists, 1990.

EAD Tag Library

Gilliland-Swetland, Anne J. and Thomas A. La Porte, eds. *Encoded Archival Description Document Type Definition Tag Library (DTD),* beta version, Technical Document No. 2. Chicago: Society of American Archivists, and Washington, DC: Library of Congress, 1996.

ISAD(G) Glossary

International Standard Archival Description (General)—Glossary of Terms Associated with the General Rules. Paris: International Council on Archives, Ad Hoc Commission on Descriptive Standards, 1993.

RAD Glossary

Rules for Archival Description: Glossary. Ottawa: Canadian Council of Archives, 1993.

Acronyms

AACR2
Anglo-American Cataloguing Rules. 2nd edition

AAT
Art & Architecture Thesaurus. 2nd edition

ANSI
American National Standards Institute

APPM
Archives, Personal Papers and Manuscripts

ASCII
American Standard Code for Information Interchange

DTD
Document Type Definition (in Standard Generalized Markup Language)

EAD
Encoded Archival Description

HTML
HyperText Markup Language

ISAD(G)
International Standard Archival Description–General

LCSH
Library of Congress Subject Headings

MARC
see **USMARC**

NAF
Library of Congress Name Authority File

OCLC
Online Computer Library Center

OPAC
Online Public Access Catalog

RAD
Rules for Archival Description

RLG
The Research Libraries Group

RLIN
Research Libraries Information Network

SAA
Society of American Archivists

SCM
Subject Cataloging Manual

SGML
Standard Generalized Markup Language

TGM
Thesaurus for Graphic Materials

TGN
Getty Thesaurus of Geographic Names

ULAN
Union List of Artist Names

USMARC
MAchine Readable Cataloging

XML
Extensible Markup Language

Z39.50
An information retrieval protocol that supports communication among different information systems, making it possible for a user to search various systems without knowing the different search syntaxes employed.

Bibliography

Further Reading. This section of the bibliography contains citations for works dealing with many aspects of archival practice. Many are considered basic texts in the field, and a large number of them are available through the Publications Office of the Society of American Archivists.

Tools and Technical Resources. This section contains citations for the various descriptive tools and standards employed in archival description. Most of these citations include the addresses of Web sites where you can obtain further information about the resources and their availability.

Further Reading

Aluri, Rao D., Alasdair Kemp, and John J. Boll. *Subject Analysis in Online Catalogs*. Englewood, CO: Libraries Unlimited, Inc., 1991.

"Archival Descriptive Standards: Establishing a Process for Their Development and Implementation: Report of the Working Group on Standards for Archival Description." *American Archivist* 52 (Fall 1989).

Baca, Murtha, ed. *Introduction to Metadata: Pathways to Digital Information*. Los Angeles: Getty Information Institute, 1998.

Bearman, David A. *Archival Methods*. Pittsburgh: Archives & Museum Informatics, 1989.

Bearman, David A. and Richard H. Lytel. "The Power of the Principle of Provenance." *Archivaria* 21 (Winter 1985–86): 14–27.

Bellardo, Lewis and Lynn Lady Bellardo. *A Glossary for Archivists, Manuscript Curators, and Records Managers*. Chicago: Society of American Archivists, 1992.

Chan, Lois Mai. *Library of Congress Subject Headings: Principles and Applications*. Littleton, CO: Libraries Unlimited, 1978.

Daniels, Maygene and Timothy Walch, eds. *A Modern Archives Reader: Basic Readings on Archival Theory and Practice*. Washington, DC: National Archives Trust Fund Board, 1984.

Dollar, Charles M. *Archival Theory and Information Technologies: The Impact of Information Technologies on Archival Principles and Methods*. Ancona, Italy: University of Macerata, 1992.

Dooley, Jackie M. "Subject Indexing in Context." *American Archivist* 55 (Spring 1992): 344–354.

Duckett, Kenneth W. *Modern Manuscripts: A Practical Manual for Their Management, Care, and Use*. Nashville: American Association for State and Local History, 1975.

Ellis, Judith, ed. *Keeping Archives*. 2nd ed. Porte Melbourne, Victoria: Australian Society of Archivists, 1993.

Ham, Gerald F. *Selecting and Appraising Archives and Manuscripts*. Chicago: Society of American Archivists, 1992.

Harrison, Donald Fisher, ed. *Automation in Archives*. Washington, DC: Mid-Atlantic Regional Archives Conference, 1993.

Holmes, Oliver W. "Archival Arrangement—Five Different Operations at Five Different Levels." *A Modern Archives Reader*. Eds. Maygene Daniels and Timothy Walch. Washington, DC: National Archives Trust Fund Board (1984): 162–180.

Hunter, Greg. *Developing and Maintaining Practical Archives*. New York: Neal Schuman Publishers, 1997.

Kesner, Richard and Lisa Weber. *Automating the Archives: A Beginner's Guide*. Chicago: Society of American Archivists, 1991.

Lanzi, Elisa. *Introduction to Vocabularies: Enhancing Access to Cultural Heritage Information*. Los Angeles: Getty Information Institute, 1998.

Livelton, Trevor. *Archival Theory, Records, and the Public*. Chicago: Society of American Archivists. Metuchen, NJ: Scarecrow Press, Inc., 1995.

A Manual for Small Archives. Vancouver: Archives Association of British Columbia, 1994.
http://www.harbour.com/AABC/publicat.html

Miller, Fredric M. *Arranging and Describing Archives and Manuscripts*. Chicago: Society of American Archivists, 1990.

Nesmith, Tom, ed. *Canadian Archival Studies and the Rediscovery of Provenance*. Metuchen, NJ: Scarecrow Press, 1992.

O'Toole, James M. *Understanding Archives and Manuscripts*. Chicago: Society of American Archivists, 1991.

Petersen, Toni and Pat Molholt, eds. *Beyond the Book: Extending MARC for Subject Access*. Boston: G.K. Hall, 1990.

The Principle of Provenance: First Stockholm Conference on Archival Theory and the Principle of Provenance. Stockholm: Swedish National Archives, 1994.

Ritzenhaler, Mary Lynn. *Preserving Archives and Manuscripts*. Chicago: Society of American Archivists, 1993.

Schellenberg, Theodore R. *Modern Archives: Principles and Techniques.* Chicago: University of Chicago Press, 1956. Society of American Archivists Archival Classics reprint, 1996.

Smiraglia, Richard P., ed. *Describing Archival Materials: The Use of the MARC AMC Format.* New York: Haworth Press, 1990.

"Standards for Archival Description: Background Papers." *American Archivist* 53 (Winter 1990).

Subject Indexing for Archives. Bureau of Canadian Archivists. Planning Committee on Descriptive Standards. Publication No. 4. Ottawa: Bureau of Canadian Archivists, 1992.

Swartzburg, Susan. *Preserving Library Materials: A Manual.* 2nd ed. Metuchen, NJ: Scarecrow Press, 1995.

Tibbo, Helen R. "The EPIC Struggle: Subject Retrieval from Large Bibliographic Databases." *American Archivist* 57 (Spring 1994): 310–326.

Weber, Lisa B. "Archival Description Standards: Concepts, Principles, and Methodologies." *American Archivist* 52 (Fall 1989): 504–513.

Yakel, Elizabeth. *Starting an Archives.* Chicago: Society of American Archivists, 1994.

Zinkham, Helena, Patricia D. Cloud, and Hope Mayo. "Providing Access by Form of Material, Genre, and Physical Characteristics: Benefits and Techniques." *American Archivist* 52, no. 3 (Summer 1989): 300–319.

Tools and Technical Resources

Anglo-American Cataloguing Rules. 2nd edition. 1988 Revisions & 1993 Amendments. Electronic version 1.0/CD-ROM format. Chicago: American Library Association. 1988, 1993.
http://www.ala.org/market/books/technical.html

Art & Architecture Thesaurus. 2nd ed. New York: Oxford University Press, 1994.
http://www.gii.getty.edu/vocabulary/aat.html

Binding Terms: A Thesaurus for Use in Rare Book and Special Collections Cataloguing. Chicago: American Library Association, Association of College and Research Libraries, 1988.
http://www.ala.org/acrl/pubscat.html#speccol

Encoded Archival Description. http://lcweb.loc.gov/ead/

General International Standard Archival Description ISAD(G). Ad hoc Committee on Descriptive Standards. Paris: International Council on Archives, 1993.
http://www.archives.ca/ica/cds/isad(g)e.html

Genre Terms: A Thesaurus for Use in Rare Book and Special Collections Cataloguing. 2nd ed. Chicago: American Library

Association, Association of College and Research Libraries, 1991.
http://www.ala.org/acrl/pubscat.html#speccol

Getty Thesaurus of Geographic Names. Getty Information Institute, copyright 1998.
http://www.gii.getty.edu/vocabulary/tgn.html

Hensen, Steven. *Archives, Personal Papers, and Manuscripts: A Cataloging Manual for Archival Repositories, Historical Societies, and Manuscript Libraries.* 2nd ed. Chicago: Society of American Archivists, 1990.
http://www.archivists.org/publications/catalog/description.html

Library of Congress Name Authority File. Washington, DC: Library of Congress, continuously updated.
http://lcweb.loc.gov/cds/name_aut.html

Library of Congress Subject Headings. 20th ed. Washington, DC: Library of Congress, Office for Subject Cataloging Policy, 1993–. Annual. Also available as CDMARC *Subjects.* Washington, DC: Library of Congress, Cataloging Distribution Service, 1988–. Quarterly, each issue cumulative.
http://lcweb.loc.gov/cds/lcsh.html

Matters, Marion. *Automated Records and Techniques in Archives: A Resource Directory.* Chicago: Society of American Archivists, 1990.
http://www.archivists.org/publications/catalog/infotech.html

————. *Introduction to the USMARC Format for Archival and Manuscripts Control.* Chicago: Society of American Archivists, 1990.
http://www.archivists.org/publications/catalog/description.html

————. *Oral History Cataloging Manual.* Chicago: Society of American Archivists, 1995.
http://www.archivists.org/publications/catalog/description.html

Paper Terms: A Thesaurus for Use in Rare Book and Special Collections Cataloguing. Chicago: American Library Association, Association of College and Research Libraries, 1990.
http://www.ala.org/acrl/pubscat.html#speccol

Parker, Elizabeth Betz, comp. *Graphic Materials: Rules for Describing Original Items and Historic Collections.* Washington, DC: Library of Congress, 1982.
http://lcweb.loc.gov/cds/train.html#gavm

Printing & Publishing Evidence: A Thesaurus for Use in Rare Book and Special Collections Cataloguing. Chicago: American Library Association, Association of College and Research Libraries, 1986.
http://www.ala.org/acrl/pubscat.html#speccol

Provenance Evidence: A Thesaurus for Use in Rare Book and Special Collections Cataloguing. Chicago: American Library Association, Association of College and Research Libraries, 1988.
http://www.ala.org/acrl/pubscat.html#speccol

Rules for Archival Description. Ottawa: Bureau of Canadian Archivists, 1990.
http://www.CdnCouncilArchives.ca/pubs_e.html

SAA Directory of Archival Education in the United States and Canada 1997–98. Chicago: Society of American Archivists, 1997.
http://www.archivists.org/education/aredu.html

Subject Cataloging Manual: Subject Headings. 5th ed. Washington, DC: Library of Congress, 1996.
http://lcweb.loc.gov/cds/lcsh.html#scmsh

Thesaurus for Graphic Materials I: Subject Terms. Washington, DC: Cataloging Distribution Service, Library of Congress, 1995.
http://lcweb.loc.gov/cds/train.html#gavm

Thesaurus for Graphic Materials II: Genre and Physical Characteristic Terms. Washington, DC: Cataloging Distribution Service, Library of Congress, 1995.
http://lcweb.loc.gov/cds/train.html#gavm

Type Evidence: A Thesaurus for Use in Rare Book and Special Collections Cataloguing. Chicago: American Library Association, Association of College and Research Libraries, 1990.
http://www.ala.org/acrl/pubscat.html#speccol

Union List of Artist Names. New York: G. K. Hall, 1994.
http://www.gii.getty.edu/vocabulary/ulan.html

USMARC Format for Authority Data. Washington, DC: Cataloging Distribution Service, Library of Congress, 1993.
http://lcweb.loc.gov/marc/authority/ecadhome.html

USMARC Format for Bibliographic Data. Washington, DC: Cataloging Distribution Service, Library of Congress, 1992–.
http://lcweb.loc.gov/marc/

Walch, Victoria Irons, comp. *Standards for Archival Description: A Handbook.* Chicago: Society of American Archivists, 1993.

White-Hensen, Wendy. *Archival Moving Image Materials: A Cataloging Manual.* Washington, DC: Motion Picture, Broadcasting and Recorded Sound Division, Library of Congress, 1984.
http://lcweb.loc.gov/cds/train.html#mim

Web Resources

Organizations

ACA

The Association of Canadian Archivists home page has information about the association, its membership, conferences, publications, and activities.
http://www.archives.ca/aca/

CCA

The Canadian Council on Archives has information about its publications, the national and provincial archival associations, and a list of archival repositories in Canada.
http://www.CdnCouncilArchives.ca/

GII

The Getty Information Institute maintains at its site information on its numerous projects and initiatives in the area of cultural heritage information, including the Vocabulary Program and Research Databases.
http://www.gii.getty.edu

ICA

The International Council on Archives site has links to its publications, working groups, and special interest sections.
http://www.archives.ca/ica/cgi-bin/ica?01_e

NUCMC

The National Union Catalog of Manuscript Collections (NUCMC) has, as part of its site, a directory with links to state, regional, and local archival associations.
http://lcweb.loc.gov/coll/nucmc/society.html

Professional Organizations in Information Science

An extensive listing of library, archival, and other information science-related organizations. Maintained by the CSU School of Library and Information Science at San Jose State University.
http://witloof.sjsu.edu/peo/organizations.html

SAA

The Society of American Archivists site includes information about its extensive list of professional publications, educational opportunities, its annual conference, and many other activities.
http://www.archivists.org

Further Training and Education

Archival Education Programs in New England

This page, part of the Web site of New England Archivists, lists archival education programs in New England, and gives contact information for the programs.
http://www.lib.umb.edu/newengarch/InternetResources/educprogs/index.html

Archives Association of British Columbia's Community Archives Education Program

The program is designed to provide fundamental-level education courses to individuals working with archival materials. The two-day workshops cover such topics as care and handling of photographs, archival arrangement and description, conservation management, and emergency planning.
http://www.harbour.com/AABC/caep.html

International Archival Resources

This site has links to universities that offer archival education programs. Not a complete list, but includes some in the UK, Germany, Israel, and Canada that are not mentioned elsewhere.
http://www.usask.ca/archives/internat.html

Library of Congress Training Tools

Library of Congress Cataloging Manual and Training Tools. At this site you will find a variety of specialized training tools for cataloging different types of materials, descriptive cataloging, and subject cataloging.
http://lcweb.loc.gov/cds/train.html

LIS on the Web

This site has an extensive list of links to colleges and universities with programs in Library and Information Science, some of which offer archival education courses.
http://www.itcs.com/topten/libschools.html

NARA Workshops

A page on the National Archives and Record Administration (NARA) site that deals with training workshops in Washington, DC, and at Regional Centers. Focus on records management.
http://www.nara.gov/nara/rm/rmtrain.html

NUCMC Education Links

At the National Union Catalog of Manuscript Collections (NUCMC) site are links to colleges and universities that offer archival education programs not listed in the *SAA Directory of Archival Education in the United States and Canada 1997–1998.*
http://lcweb.loc.gov/coll/nucmc/educate.html

Professional Development Training Program

The Archives Association of Ontario sponsors a series of archival education workshops at basic and advanced levels, continuing education seminars, and jointly sponsored training opportunities.
http://www.fis.utoronto.ca/groups/aao/pd/aao001.htm

SAA

The Society of American Archivists education page has information about archival education in the US and Canada, how to locate student chapters of SAA, frequently asked questions concerning continuing education, and a schedule of upcoming SAA workshops. The *SAA Directory of Archival Education in the United States and Canada 1997–1998* (http://www.archivists.org/education/prog.html) has a useful set of links to graduate archival education and continuing education programs, as well as information on how to order a copy of this publication.
http://www.archivists.org/education.html

Examples

The EAD at Duke

Provides access to various online projects at Duke University Special Collections Library using the Encoded Archival Description (EAD), and provides technical information related to applications of SGML and the EAD Document Type Definition (DTD).
http://scriptorium.lib.duke.edu/findaids/ead/

EAD—Sites

Examples of various EAD implementations on the Web from the Library of Congress EAD home page.
http://www.loc.gov/ead/eadsites.html

Documenting the American South

This project from the University of North Carolina–Chapel Hill has digitized primary source materials dealing with the southern experience in the 19th century and written by Southerners. The texts have been encoded according to Text Encoding Initiative Guidelines and are available in both SGML and HTML versions at this site.
http://sunsite.unc.edu/docsouth/

Multilevel Archival Descriptions

A demonstration site providing access to multilevel descriptions and finding aids at the South Carolina Historical Society.
http://www2.citadel.edu/cgi-win/pf1.exe?Vanderhorst+family+&G=&50&1&

General Sites of Interest

Archives and Archivists

This site, maintained by John B. Harlan, has connections to archival organizations, resources such as the Library of Congress American Memory project, information on subscribing to the list, and a link to the list's archives.
http://www.angelfire.com/oh/harlanjohnb/archives.html

The Cataloger's Reference Shelf

This site from the Library Corporation has links to all the MARC formats, as well as to cataloging manuals for a variety of types of materials.
http://www.tlcdelivers.com/tlc/refshelf.htm

The Cataloguer's Toolbox

From the Queen Elizabeth II Library at Memorial University of Newfoundland. It includes extensive links to cataloging tools which can be accessed according to format (e.g., music, serials). Also has links to many Library of Congress resources, a list of national libraries, and other resources of interest to archivists.
http://www.mun.ca/library/cat/index.html

International Archival Resources on the Web

This site at the University of Saskatchewan Archives offers links to professional associations, institutions offering archival education, and sites concerned with standards, preservation and conservation, electronic records, and more.
http://www.usask.ca/archives/internat.html

Ready, Net, Go! Archival Internet Resources

A comprehensive site with information about professional development, tools for archivists, archival search engines, and more. Created and maintained by Leon C. Miller at Tulane University.
http://www.tulane.edu/~lmiller/ArchivesResources.html

Reference at Your Desk

This is a NARA Library site with good reference links of interest to archivists, including law and legal resources, government documents, language reference sources, and military and geographical information.
http://www.nara.gov/nara/naralibrary/weblinks/yourdesk.html

Repositories of Primary Resources

This site at the University of Idaho maintains extensive links to archival repositories around the world with holdings of manuscripts, rare books, historical photographs, and other primary sources. The list of repositories is divided regionally.
http://www.uidaho.edu/special-collections/Other.Repositories.html

Resources of the Rare Materials Cataloger

This site, aimed at catalogers of rare materials, provides a rich list of resources such as sites of foreign language cataloging tools, geographic and personal names tools, reference sites, and other special collections and rare book links. Created by Eric Holzenberg of the Grolier Club Library and Larry Creider of the University of Pennsylvania Libraries. Sponsored by the Bibliographic Standards Committee of the Rare Books and Manuscripts Section, Association of College and Research Libraries.
http://www.library.upenn.edu/ipc/index.html

Special Collections Web Resources

Extensive list of various types of resources for special collections: organizations and associations, lists and discussions, government agencies, reference materials, and online exhibits.
http://info.lib.uh.edu/speccoll/specoweb.htm

UK World Wide Web Resources: Libraries and Archives

This site at the University of Kentucky has links to many archival repositories and libraries, both general and specialized.
http://www.uky.edu/Subject/libraries.html